WHAT IS ZENTANGLE®? • • • • • • • • • • • • • 4
WHY TANGLES? • • • • • • • • • • • • • • • • • 5
THE NEXT STEP • • • • • • • • • • • • • • • • • 5
MAKE YOUR OWN TANGLES • • • • • • • • • • 158

3 Squaredaze · 6

AHH · 10

Amoeba · 14

Bales · 18

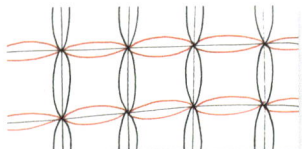

Beeline · 22

Brella · 26

Cubine · 30

Dinoflor · 34

Gewurtz · 38

Gneiss · 48

Hollibaugh · 52

Huggins · 56

Intersection · 60

Jonqal · 64

Knightsbridge · 68

Lashes · 72

Lee-Bee · 76

Maryhill · 80

Papermint · 90

Poke Heart · 94

Puchong · 98

Puf · 102

Ovy · 106

Shattuck · 110

Trangle · 114

Starcrossed · 118

Static · 122

Y-Ful Power · 132

Zinger · 136

Knase · 140

Pezember · 144

Rain · 148

WHAT IS ZENTANGLE®?

The Zentangle method, created by Rick Roberts and Maria Thomas, is an easy-to-learn, relaxing way to create beautiful images by drawing structured patterns. **No artistic or writing talent required!** Tangles are merely a series of repeated lines, dots, and shapes. You can record your thoughts with simple words and phrases or long paragraphs—whatever works for you.

Simple, portable tools. All you need for Zentangle is a pen and paper: no eraser! Just as life's mistakes can't be erased, misplaced marks in Zentangle art shouldn't be erased. Incorporate the "mistakes" in your art—own them and turn them into something positive.

Purposeful. Unlike doodling, where marks are made randomly, with the Zentangle method, every pen stroke is very deliberate and intentional. Use it in this journal to focus your mind for meditation or relaxation.

New perspective. Once you start tangling, you will see patterns everywhere—on fabric, in architecture, and in nature. You will find yourself appreciating the simplicity or complexity of your surroundings.

Individualistic. Just as no two people are the same, no two tangles are the same. Don't worry about imitating someone's Zentangle art. Strive to give each Zentangle piece a bit of your own style and personality.

WHY TANGLE?

When you take the time to tangle, you'll get a sense of peace and calm. Just like eating right or exercising regularly, tangling is a life skill that can benefit anyone. It can be a powerful way of journaling—"detangling"—your thoughts and emotions. Tangling can help you in so many ways:

- Increases creativity and problem solving
- Creates a sense of peace and calm
- Lowers stress
- Produces a sense of accomplishment and confidence
- Increases focus and concentration

THE NEXT STEP

Ready to begin? Pick up your pen and select a tangle you'd like to try. Use the blank pages in this journal to practice the sample tangle or improvise your own. Each sample tangle is broken down into steps.

As you tangle, think about a problem you're facing or a decision you need to make. Or tangle as you listen to a sermon or special music. The lined pages provide space to record your thoughts as you tangle. Clarity will often come as you "detangle" your jumbled ideas by using Zentangle.

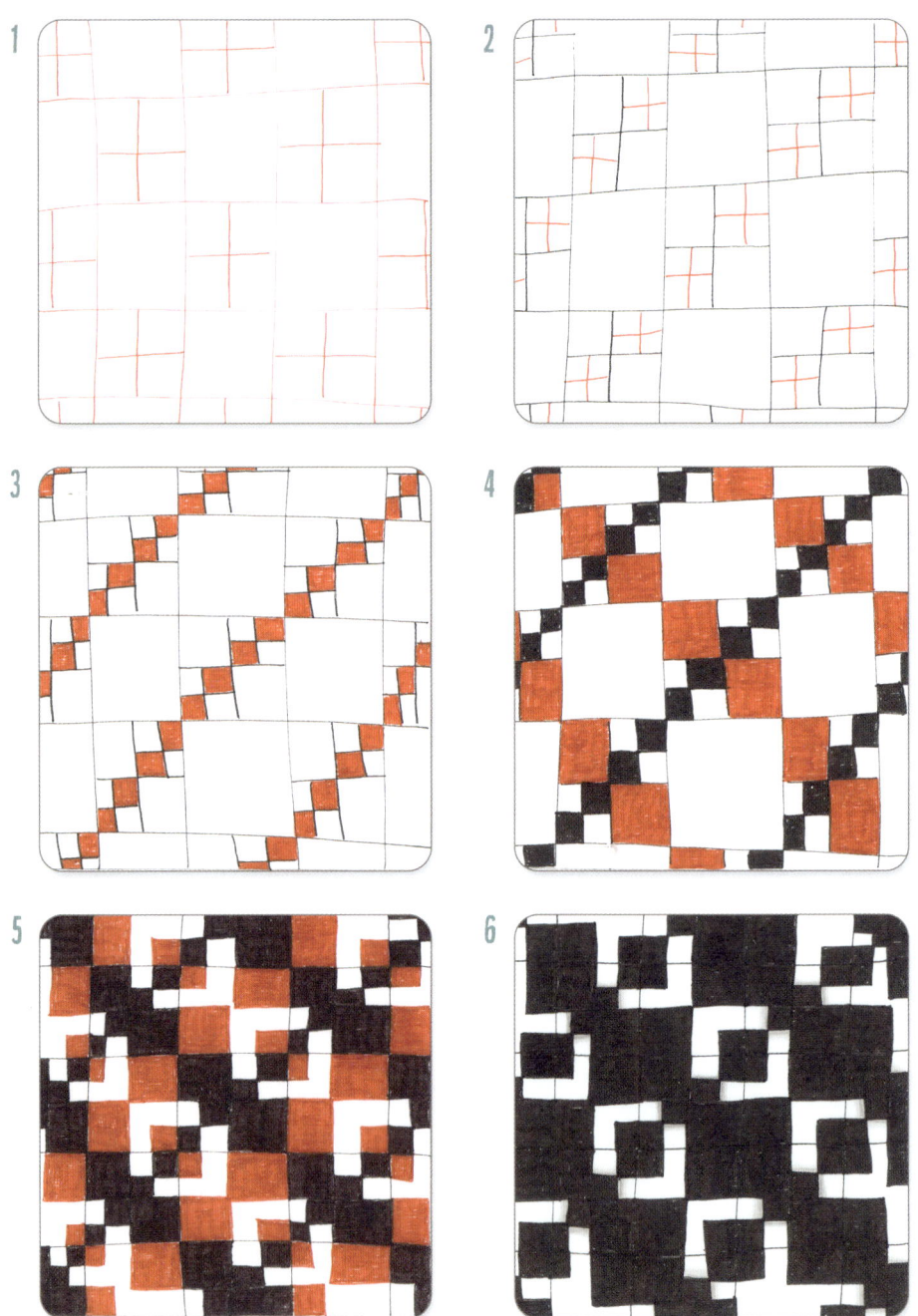

3 Squaredaze by Cindy Fahs, CZT

"Anything is possible, one stroke at a time."
–Rick Roberts & Maria Thomas, founders of Zentangle®

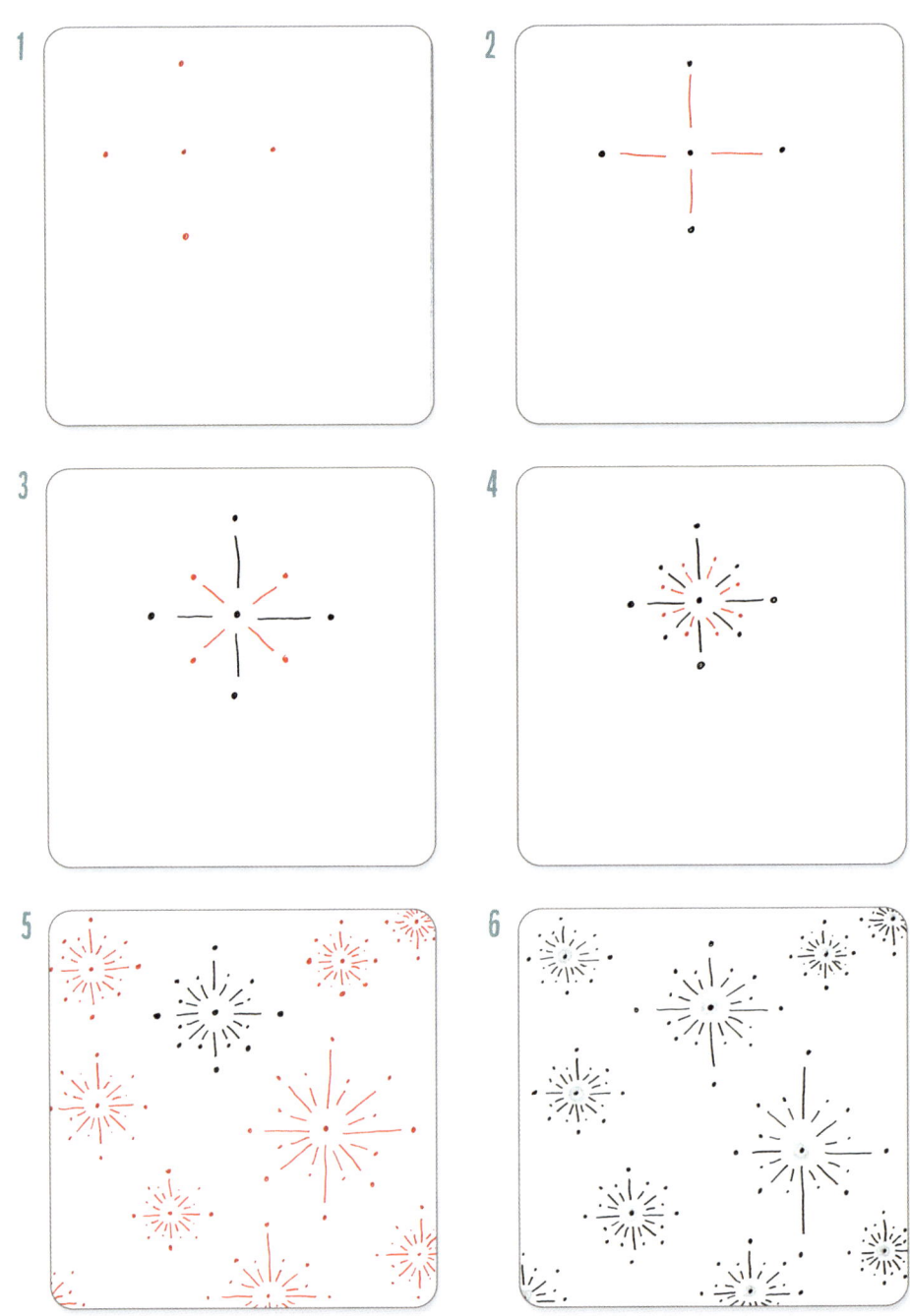

AHH by Rick Roberts & Maria Thomas, Original Zentangle®

"Tangles are very representative of life's problems—if you break a problem down into little pieces, it doesn't seem as overwhelming, and it is much easier to overcome."

–from *Joy of Zentangle*

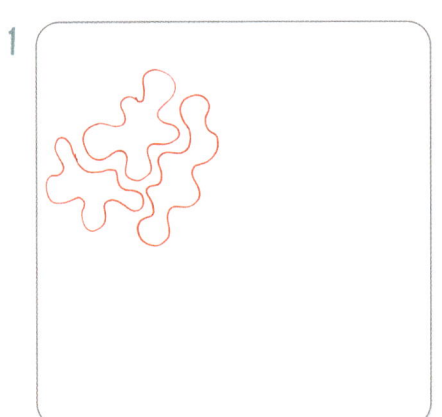
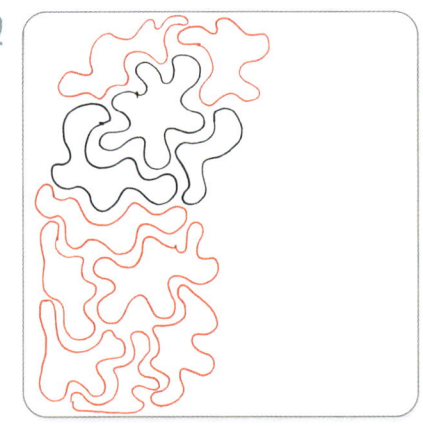
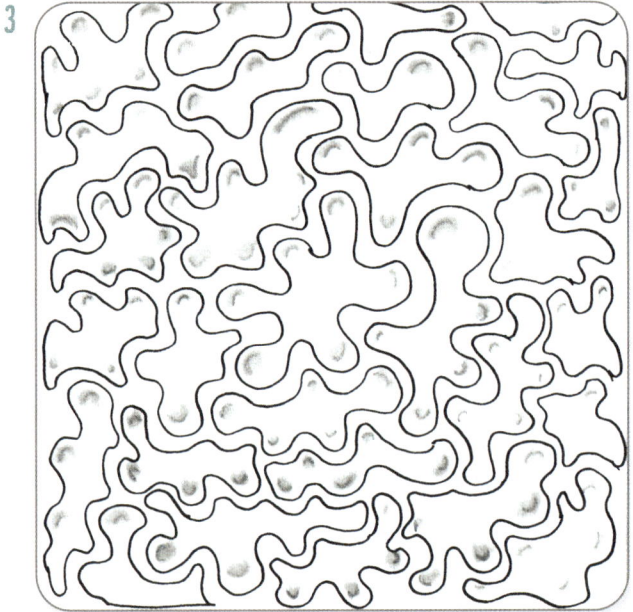

Amoeba by Rick Roberts & Maria Thomas, Original Zentangle®

"You can't go back and make a new start, but you can start right now and make a brand new ending."

–James R. Sherman

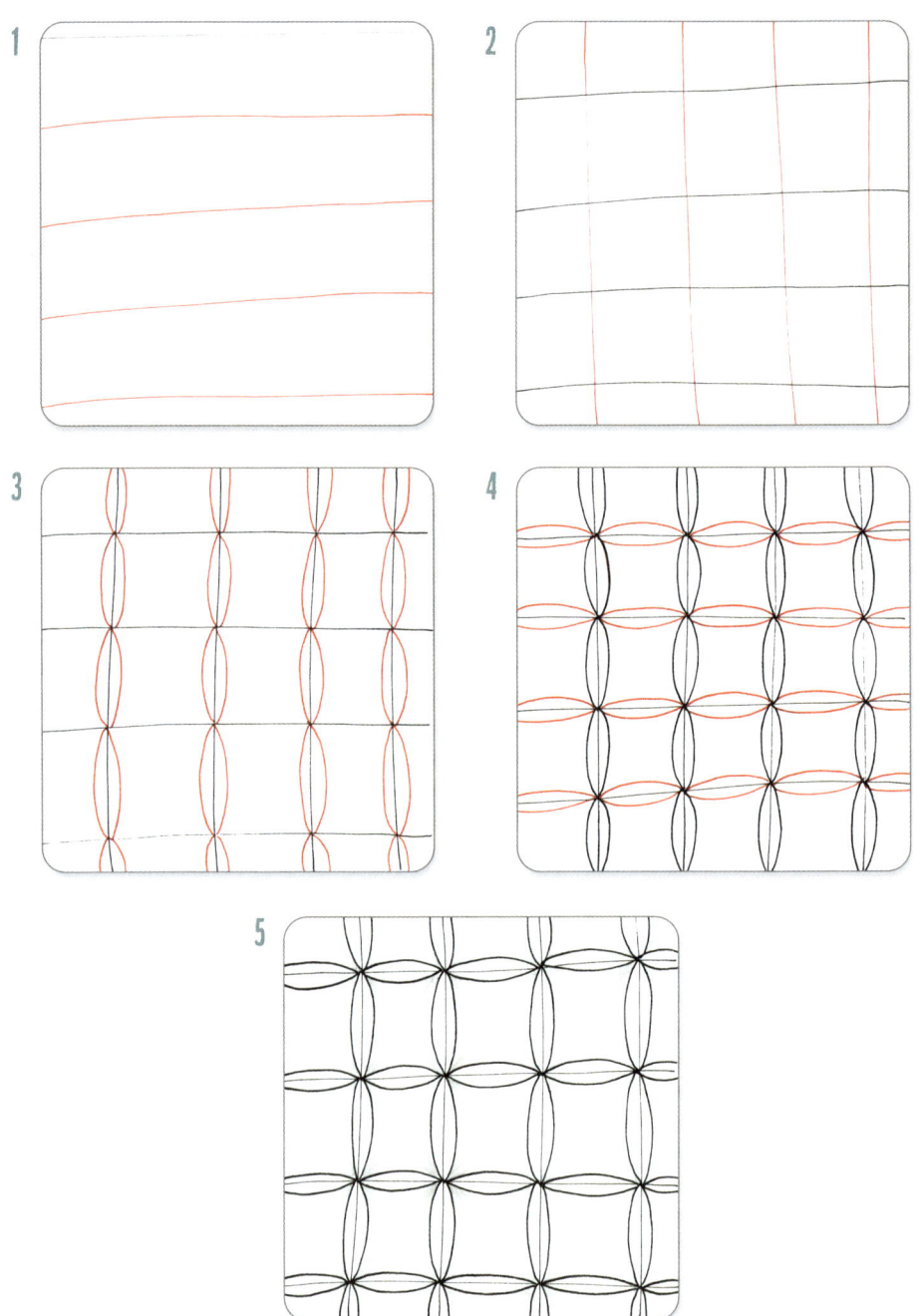

Bales by Rick Roberts & Maria Thomas, Original Zentangle®

"Don't judge each day by the harvest you reap but by the seeds you plant."

–Robert Louis Stevenson

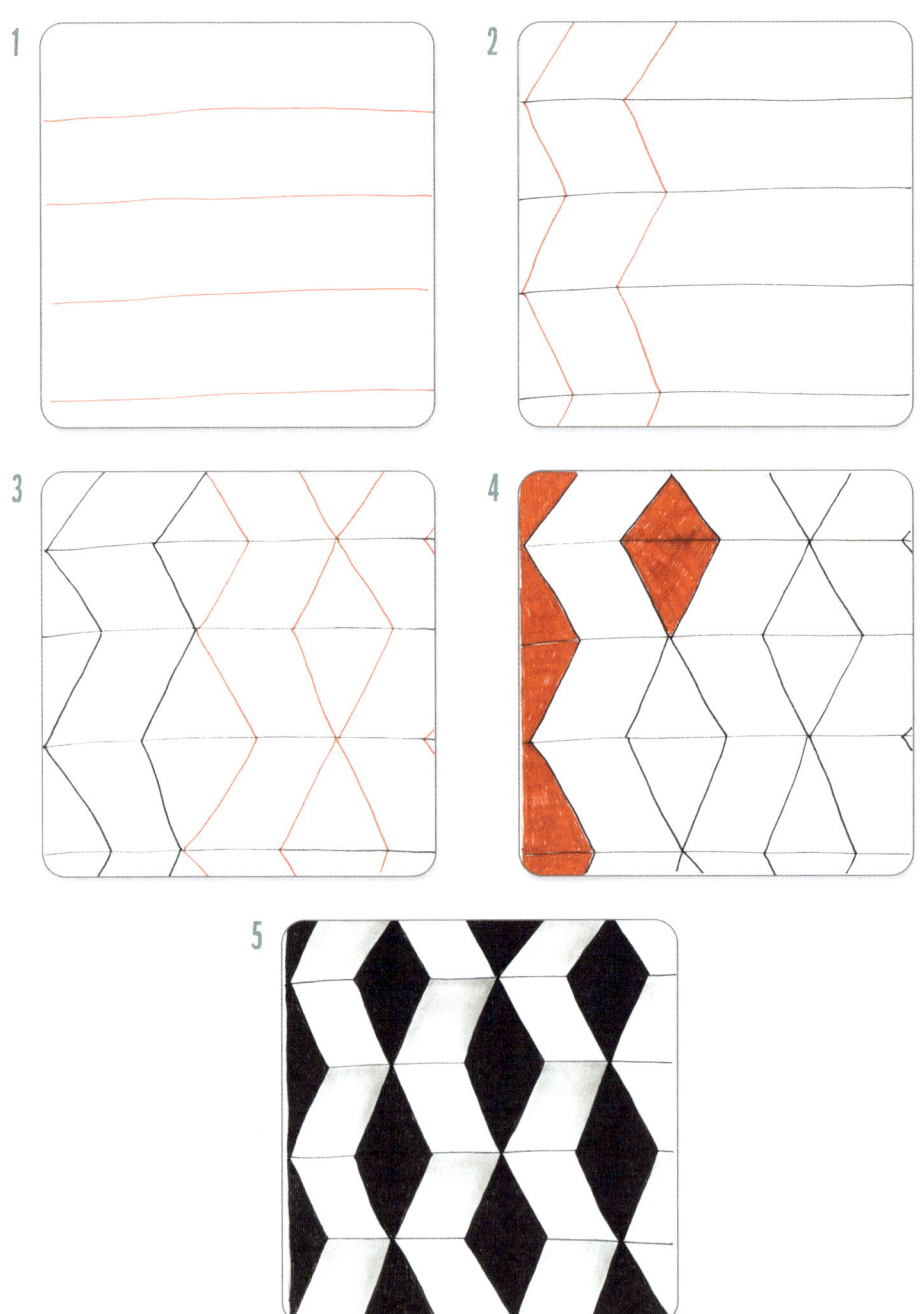

Beeline by Rick Roberts & Maria Thomas, Original Zentangle®

"Somewhere, something incredible is waiting to be known."
—Sharon Begley

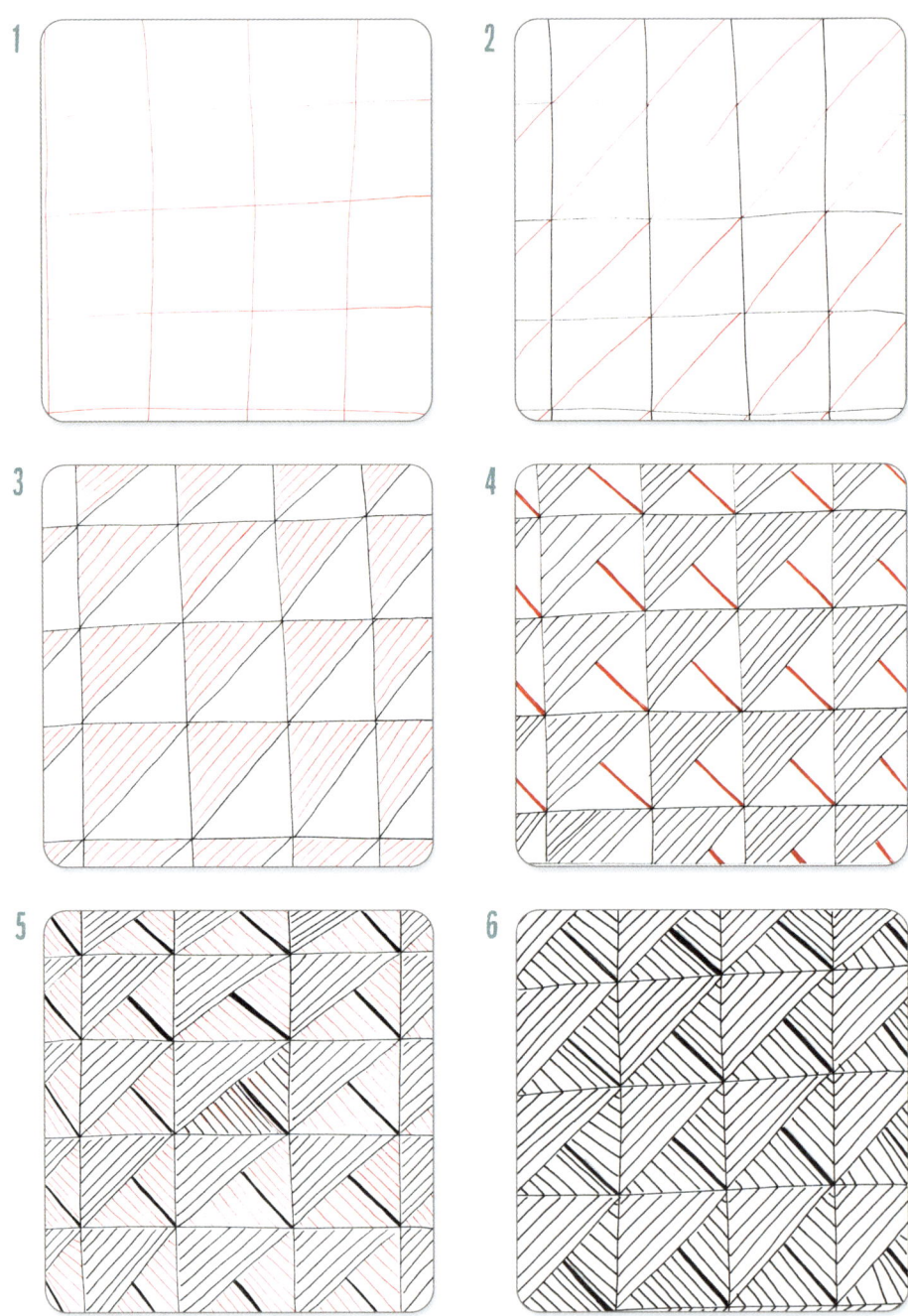

Brella by Frances "Bunny" Wright, CZT

"A house is a home when it shelters the body and comforts the soul."

–Phillip Moffit

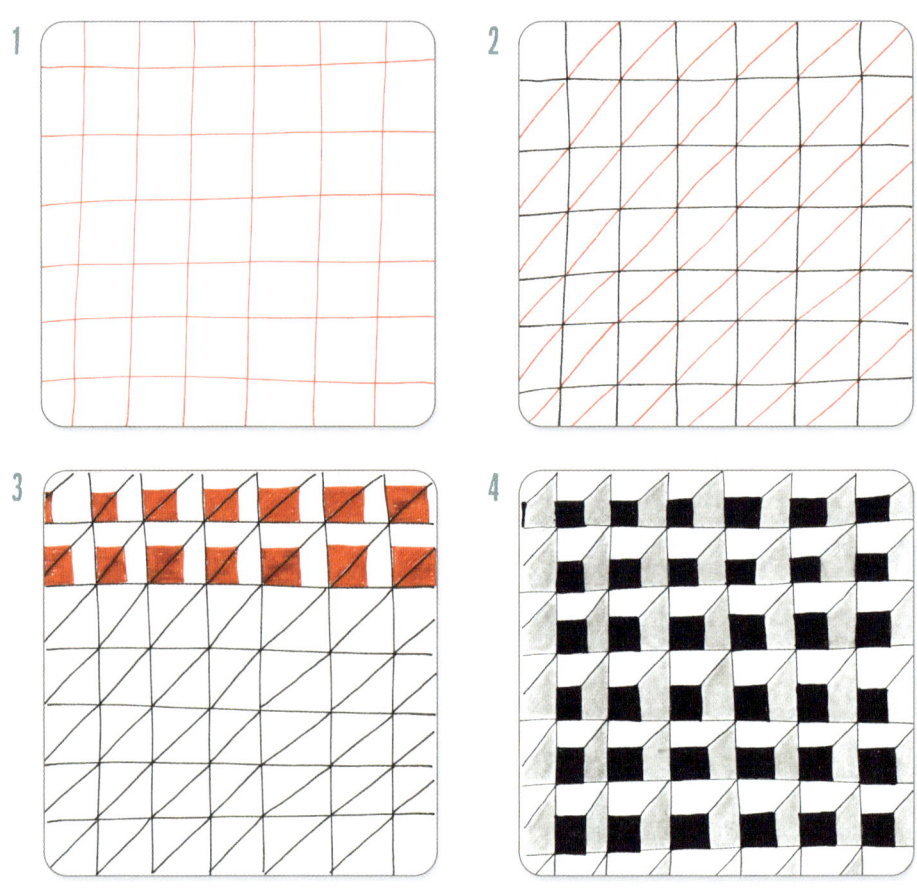

Cubine by Rick Roberts & Maria Thomas, Original Zentangle®

"Remember the tea kettle: it is always up to its neck in hot water, yet it still sings."

–Unknown

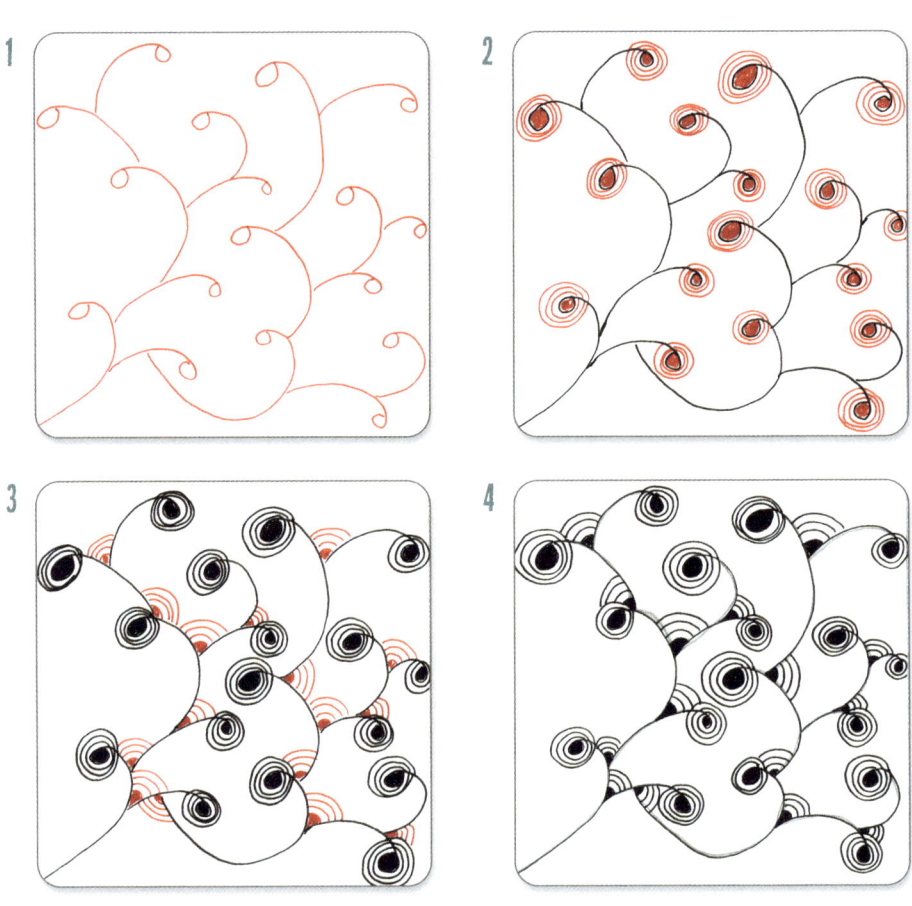

Dinoflor by Suzanne Fluhr, CZT

"Don't hurry, don't worry. And be sure to smell the flowers along the way."

–Walter Hagen

Gewurtz by Linda Farmer, CZT

"The two most important days in your life are the day you were born and the day you find out why."

–Mark Twain

For Scott by Cindy Fahs, CZT

"Life is a building process. All events and experiences are incorporated into our learning process and into our life patterns."
–from *Zentangle 11, Workbook Edition*

Gneiss by Rick Roberts & Maria Thomas, Original Zentangle®

"Why fit in when you were born to stand out."

—Dr. Seuss

1
2
3
4

Variation

Hollibaugh by Rick Roberts & Maria Thomas, Original Zentangle®

52

"There is nothing ugly... light, shade, and perspective will always make it beautiful."

–John Constable

Huggins by Rick Roberts & Maria Thomas, Original Zentangle®

"If only we could pull out our brain and use only our eyes."
—Pablo Picasso

Intersection by Suzanne McNeill, CZT

"You can't use up creativity. The more you use, the more you have."

—Maya Angelou

Jonqal by Rick Roberts & Maria Thomas, Original Zentangle®

"Social media has colonized what was once a sacred space occupied by emptiness: the space reserved for thought and creativity."

–Mahershala Ali

Knightsbridge by Rick Roberts & Maria Thomas, Original Zentangle®

"If you're not doing some things that are crazy, then you're doing the wrong things."

–Larry Page

Lashes by Cindy Fahs, CZT

"Art, freedom and creativity will change society faster than politics."

–Victor Pinchuk

Lee-Bee by Sue Schneider, CZT

"We adore chaos because we love to produce order."
—M. C. Escher

Maryhill by Betsy Wilson, CZT

"The question isn't who is going to let me; it's who is going to stop me."

–Derived from *The Fountainhead* by Ayn Rand

By Cindy Fahs, CZT

"If you want something new, you have to stop doing something old."

—Peter F. Drucker

1
2
3
4
5

Papermint by Sandy Hunter, CZT

"Ideas come from everything."

–Alfred Hitchcock

Poked Heart by Cindy Fahs, CZT

"We don't make mistakes, just happy little accidents."

–Bob Ross

1
2
3
4
5

Puchong by Michelle Lim, CZT

98

"Creativity is allowing yourself to make mistakes. Art is knowing which ones to keep."

–Scott Adams

Puf by Carole Ohl, CZT

"The worst enemy to creativity is self-doubt."

–Sylvia Plath

Ovy by Adam Roades

"Make an empty space in any corner of your mind, and creativity will instantly fill it."

–Dee Hock

Shattuck by Rick Roberts & Maria Thomas, Original Zentangle®

"Any activity becomes creative when the doer cares about doing it right or better."

–John Updike

1
2
3
4
5

Trangle by Jody Genovese, CZT

"One sure-fire way to stay creative: force yourself to learn something new."

–Harvey Mackay

Starcrossed by Jenna Black

"Art is the only way to run away without leaving home."

–Twyla Tharp

Static by Rick Roberts & Maria Thomas, Original Zentangle®

122

"I found I could say things with color and shapes that I couldn't say any other way—things I had no words for."

–Georgia O'Keeffe

By Cindy Fahs, CZT

"Life beats down and crushes the soul and art reminds you that you have one."

—Stella Adler

Y-Ful Power by Shoshi

"The artist is not a special kind of [person]; rather each [person] is a special kind of artist."

–Ananda Coomaraswamy

Zinger by Rick Roberts & Maria Thomas, Original Zentangle®

"Be yourself. Embrace your quirks."

—Ed Sheeran

Knase by Rick Roberts & Maria Thomas, Original Zentangle®

"What art offers is space—a certain breathing room for the spirit."

–John Updike

Pezember by Peter Fruehwirt, CZT

"A line is a dot that went for a walk."
—Paul Klee

1 2 3 4 5 6

Variation

Rain by Rick Roberts & Maria Thomas, Original Zentangle®

"True happiness comes from the joy of deeds well done, the zest of creating things new."

–Antoine de Saint-Exupéry

By Cindy Fahs, CZT

"Life is the art of drawing without an eraser."

—John W. Gardner

MAKE YOUR OWN TANGLE

Tangle patterns can be found in everyday objects—a rug, a bowl of fruit, or a bicycle. Using the image below as inspiration, create your very own tangle here. Begin by sketching the full tangle, and then use the other boxes to deconstruct it into simple steps. You can also practice shading or adding color or create variations of your tangle.

ISBN 978-1-64178-079-7

COPY PERMISSION: The written instructions, photographs, designs, patterns, and projects in this publication are intended for the personal use of the reader and may be reproduced for that purpose only. Any other use, especially commercial use, is forbidden under law without the written permission of the copyright holder.
NOTE: The use of products and trademark names is for informational purposes only, with no intention of infringement upon those trademarks.

Fox Chapel Publishing makes every effort to use environmentally friendly paper for printing.

© 2021 by Quiet Fox Designs, *www.QuietFoxDesigns.com*, an imprint of Fox Chapel Publishing Company, Inc., 903 Square Street, Mount Joy, PA 17552.

Illustrations by Cindy Fahs, CZT. Image source: Shutterstock.com: irin-k, page 158.

"Zentangle®," the red square, and "Anything is possible, one stroke at a time," Certified Zentangle Teacher®, and CZT® are registered trademarks of Zentangle, Inc. The Zentangle teaching method is patent pending and is used by permission. You'll find wonderful resources, a list of Certified Zentangle Teachers (CZTs), workshops, a fabulous gallery of inspiring projects, kits, supplies, tiles, pens, and more at *zentangle.com*.

We are always looking for talented authors and artists. To submit an idea, please send a brief inquiry to acquisitions@foxchapelpublishing.com.

Printed in Singapore
First printing